More Praise for

"When I started reading your book I couldn't put it down. It was so ⸻ loving and beautiful, that it moved me to tears. Thank you for sharing it with me and the w⸻ were my first friend in Carmel! Much love."

IRIS DART, *NY Times* best-selling Author, nine books, including *Beaches*

"Howard Brunn is an iconic Carmel by-the-Sea figure, rare in having been raised and schooled here, departed for war and returned, where he became a successful and popular businessman, activist, City councilman, friend, parent, and devoted husband. What he brings to life he brought to these verses and he shows through in each."

SKIP LLOYD, Attorney, Environmental Advocate, Carmel Residents Association

"Why am I surprised at the response to a love tested. That this test should produce here poetry of such delicate power and fine distinction, Quaking with reality. HB you have inspired me to weep and smile. To coalesce the dark pathways of poignancy and the light of joy. Thank you and Courtney, *Flaps Up!* "

JAY KILLEN, Designer

"*Flaps Up!* is a book from the heart of an amazing man. It is a chronological journey, through poetry and photos, of his life and love. But it is also an eloquent statement from the wisdom and optimism of a man who has lived life to its fullest."

PHILLIP BUTLER, CDR, USN (ret.), Warrior for Peace & Justice, Author *Three Lives of a Warrior,* more than seven years as a prisoner of war in Vietnam

"In *Flaps Up!* , as Howard's dear wife slips into Alzheimer's, with unadorned poetic language, elegant in its purity, Brunn shows us that absolutely nothing can separate him from his beloved Courtney."

JERRY GERVASE, Columnist, *Carmel Pine Cone*

"Howard Brunn is an example of a truly strong American combat veteran, with a passionate love for jazz. A devoted husband who has dedicated his time and never-ending love to his beautiful wife. He is truly a man to be admired."

RUTH JUAREZ, Case Manager, CNA

I'm deeply touched by your lovely poems and real pictures about life and death and everything in between. Your honest perspective and choice of words leave me laughing and crying from line to line. It's especially touching to read about how much you and Courtney truly loved and cherished each other. If that isn't the meaning of life, I don't know what is. Beautiful stuff, Howard!!

JEFF BURGHARDT, Burghardt+Doré Advertising

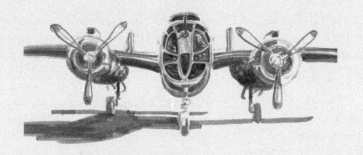

Flaps Up!

Poetry, Prose, and Pictures

HOWARD BRUNN

FLAPS UP!

First edition July 2015
Printed in the United States of America

ISBN-13: 978-1-935530-75-6

Anyone who wants to use any part of this book for any reason,
or no reason, is free to do so... HB

Book design and format by Patricia Hamilton

Published by Park Place Publications
Pacific Grove, California 93950
www.parkplacepublications.com

Available at Carmel Bay Company, local bookstores, and on-line.

Part of the proceeds from the sale of this book will be donated to the
Alzheimer's Association.

Some of the poems in this book were previously published in the
Monterey Peninsula Herald, *the* Tor House Newsletter, *and* Carmel
Pine Cone.

MORE THAN 50 YEARS OF

CARMEL MEMORIES

Best Wishes Connie

Howard Brunn

FOREWORD

Howard Brunn has created a marvelous and fresh volume of poetry, with photographs and some very clear prose.

His lines often sparkle with urgency, because Howard cares so deeply about the places, the friends, the lives he loves.

The poems communicate these feelings to "Dear Reader" with a good-humored and often elegant efficiency, and the photographs enhance the effect, sometimes painfully, sometimes playfully. There is that particular element of surprise here that is so essential to poetry, and so rare.

In Howard's best lines there are surprises worthy of life itself!

It is a blessing to know this man, this book, "Flaps Up!"

Taelen Thomas
The Lingo Kid,
Author, poet, and teller of tales

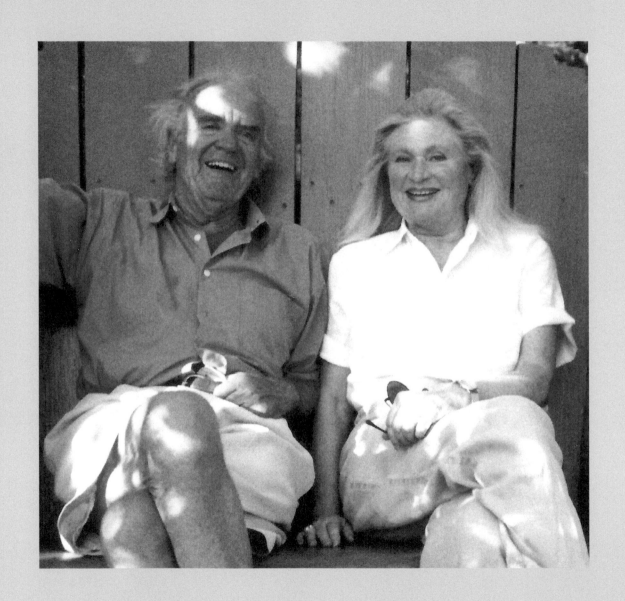

For Courtney — Naturally

Before—High School, Carmel,
CA (1942).

After— Rest leave, Rome,
Italy, (1945).

CONTENTS

Jeffers
took the stars
one by one,
then by the
handful,
threw them
beyond the sky
into the Universe.
Condor, Hawk, Stone,
the great sea below
and his promise to Una
fulfilled.
His grief and
his mortal life
complete
in their
bed
by the window.

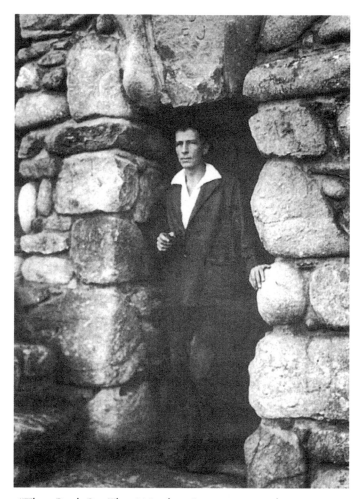

"The Bed By The Window" was an early poem in Jeffers' career. Una Jeffers did not die in the bed. Hers were a difficult final few years, complicated by cancer and other problems. She died in the local hospital. Jeffers was never the same. On January 20, 1962, it was his time. He died in the Bed by the Window.

Golden summer days,
long, long ago.

The deep silver grey
green Carmel River,
flowed to the sea.

She a teenage goddess,
Me a new and eager
Boy Scout of America.

Here can be love,
simple and easy,
carefully in one
direction only.

A generation passes.

The teenager is gone!

The summer Carmel river
no longer flows
to the sea.

The Boy Scout of America
… still loves,
and trusts,
there
is more to come.

Not knowing.

THE WHITE DRESS

The white dress
settled gracefully
into

The convertible

Leaving me

Happy and

Hopeful

So, where else had the white dress
been that moonlit night?

Under the Jackie O. glasses as I struggled to
place your face.
Across the lobby to the "be seated" station.

Special supper.

Remembering the birth of the white dress—
Versailles—the annual all-white picnic, purchased
for the occasion.

Carefully, with you, back through the welcoming
Bernardus entrance, and gracefully into the
convertible.

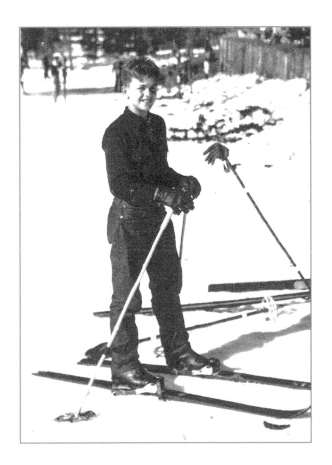

I remember a photo.
He is a great and lovely boy
standing in the snow
stocking cap, skis.

A pre-war 1939 young man
of grace … smiling.

Remember this.

Yesterday I learned
Coroners … morgue
Remains unclaimed
for almost six months.

A lonely place, cold,
What should I do?

place of death
sidewalk
social security number
Unk.
usual residence
Unknown
data, data, data
Certificate of Death
primary occupation
artist
immediate cause
Arteriosclerotic Cardiovascular
December 20, 1980
a lovely younger brother
"respectfully delivered to the sea …
cremated remains … according to the
Standards of this State…"

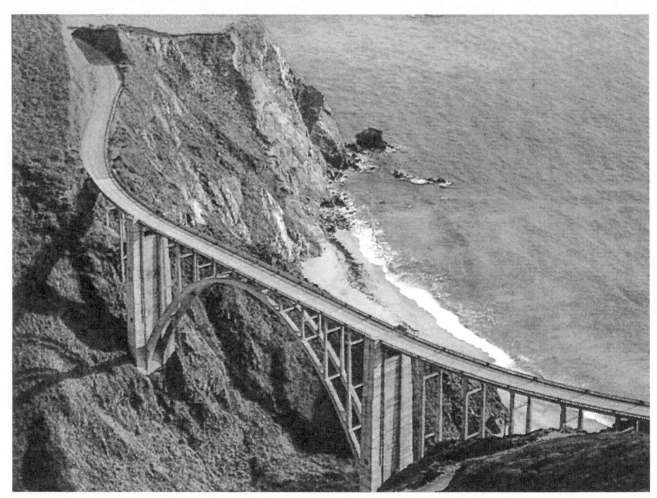

CROCODILE'S TAIL, a mid-century, two-story wooden restaurant structure, at the north end of Bixby Bridge; it hung on the cliff side and appeared ready to fall into the ocean far below. The Philippine male workers lived on the premises. A heated poker game took place in the early morning hours. In the shoot-out that occurred, four of the five men were killed. State Senator Fred Farr defended the primary shooter. He got some time … was out in a few years.

At mid-century

Far north end of Bixby Bridge
hanging 713 feet above the sea

the two-story
wooden restaurant structure

was known up and down
the Big Sur coast

as the watering hole of choice
and available lively action.

After closing time
one long night
of poker and booze

Many dead.

RICKEY REMEMBERED

Bridges beckon.
The far, far west,
the setting
Sur sun.

The circle comes,
to rest.

Dancing on the rail,
cool green below,
blue beyond.

Innocence …

Rickey jumped!

Why me, Bixby?

Rickey was a golden boy and top surfer—
got too deep into smack—jumped.

AMY REMEMBERED

In the Fifties
she waved
to her
13-year-old daughter,
who was far below.

Amy jumped.

Amy, Palmer, widow of my best friend, Dr. Frank Palmer, lived in a cabin on the creek below Bixby. Today, Amy might be labeled bi-polar. She was very stressed. Soon after this event, their daughter Mary Pat came to the basement office of our Mark Fenwick store in Carmel and Courtney held her.

Photo of Courtney by Ben Lyon.
Published in the Monterey Peninsula
Herald, *February 11, 1980.*

*Well-known local photographer, Ben Lyon (*Monterey Peninsula Herald*), was well-known to many of us. I had traveled with Ben to Alaska where his son Mark fished in the wilds. Ben had throat cancer and was slowly dying. Hospice coming around. Ben decided he did not want to linger. He got pills, gathered a bunch of us around, gathered up some keepsakes, gave a little talk. His ex-wife was present and his girl friend too. Family from the east - small apartment. Lots of tension and drama. He took the pills and lay down in the small bedroom. However, he did not die then! The lack of communication and bad feelings between the various parties boiled over. Ben was in a deep coma. They all had separate time commitments, plane tickets, jobs, etc. It was a mess. He did carefully stop breathing almost two days later. It was not easy.*

Saying goodbye to Ben was going to be easy.

He had thought it carefully through.
That day,
there was a great grey/blue cloud.
The rain would follow.

Ben knew the family stress points.
Final details pre-arranged,
paid for and
thoughtfully attended to.

(Ashes to the family plot in Le Grand, Oregon)

No service, that sort of thing.

Remove the feeding tube from the stomach.
It is only feeding the cancer.

Morphine is all I need now.

No water, no food, I'm fine.

"Did you know that you don't get hungry?"

Interesting.

Saying goodbye to Ben was not easy.

23

720 panels
from 30 nations

(and the children)

they hugged
they cried

29,000 panels
from around the world

but no one
prepared me for

(and the children)

(all the children)

In 1995 I had not learned that children die of AIDS. We were across from the museum on 3rd Street where the huge lawn was covered with the quilts traveling through the country. People hugged and cried on this lovely sunny day.

Golden twin towers
early dawn
emerges.

New York glitters
framed from a
distant window.

The dirt and filth
is lost in time

as wings and
air combine,

folding reality
into the blue
bay below.

Prior to the 9/11 destruction of the Twin Towers in the very early, still dark morning—I had just ridden in a cab through 126th Street area of New York City, a blighted, tough scene.

Lingo—Lingo—Lingo
Yes—it rhymes with Bingo

La Playa in 2002 began it all
Cavalry boys stalwart and tall.
Cavanaugh, Lingo, and very few others.
Formed "The Group" which became the brothers.

During the recent very short years,
We said goodbye and shed some tears:
Wachter—McLean—Dedine—Arriola and Gourley
Headed west—we miss them sorely.

"The Group" rides on and is now the Cavalry
… Nothing rhymes with that …
Back to the beginning and a tip of the hat.

Lingo—Lingo—Lingo
Yes—it rhymes with Bingo.

ALL TOGETHER
LINGO—LINGO—LINGO
YES—IT RHYMES WITH BINGO

Every man at Bill's had plenty
of fun.

My briggest thrills
came when I was dealt
five spades:
Big pot!
Money on the line!

Howard filled his boat
and emptied mine.

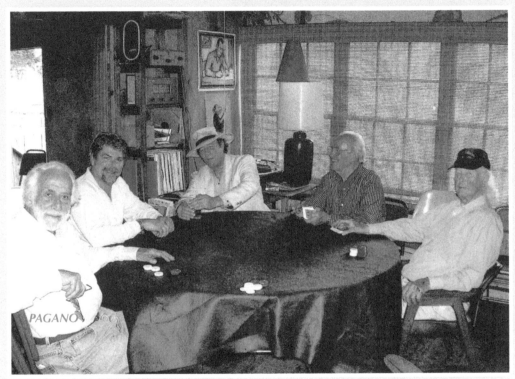

Pacific Biological Laboratory, 800 Cannery Row, Monterey. DOC'S LAB.

A stalwart son of a gun
dear friend of C.G. Jung.

Way to go—PAGANO

At the poker table he is very able
and with mirth and glee
will sweep the table

Way to go—PAGANO

On the courts he is a holy terror
hitting sideliners without an error.

Way to go—PAGANO

He speaks of wisdom and his love is great.
If you need a friend he won't be late.

Way to go—PAGANO

We say goodbye with this last line.
See you again at 99.

Way to go—PAGANO

WAY TO GO
P–A–G–A–N–O

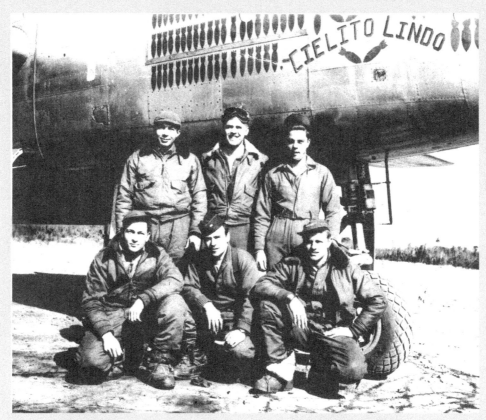

Corsica, 1944.

As the wheels of the 727
leave the runway
and,

the smooth coordinated
climbing turn to the north takes over.

A small part of my 87 years
returns,

to other times and other skies.

Dark terror and death …

Some survived.

DON

Don, Don, remember
me!

You reached the heights
of literary place
and then,
Don,
you hit the wall!

Not the wall of worry,
the wall,
the wall of
place,
the wall of reality.

The wall,
the wall,
the wall of
knowing
and being comfortable.

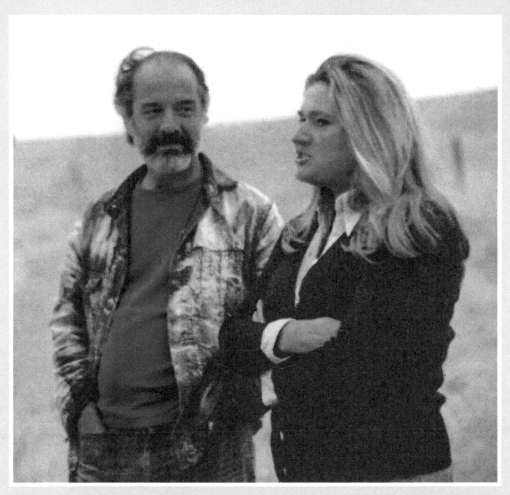

Writer Don Marsh had sold his book, Stone Humpers, *for a lot of money. He left his job and wrote full time. Never another sale. His wife had a good job. After some years he got deeply into alcohol and eventually went 12-Step— this worked. We were the closest of friends and I got him back.*

From my desk at the
Carmel Bay Company
I hired lots of people.

I always read the
Sunday *New York Times*
CEO Interview
to see how others did it.

Finally, I nailed a plan
that worked:

No one from the far Northeast—
with a New England Twang

Haaarrrvvvard.

No one from the far Western states.

The winners were ALWAYS
from the Midwest, or close by.

No. 1: Iowa.
No. 2: Minnesota/Wisconsin,
Kansas, Missouri, Indiana,
Kentucky and on and on.

Some saw the ocean for the first time
from my Ocean Avenue location.

They were honest, and did not steal.
They had common sense,
usually learned from their fathers.

They were often pretty.

And when it was time
to come to work,
they never called in
and were never late.

................................

The Great God Brown,
a streak of fire,

through the heavens,
35 thousand high feet

above the valley floor.

Clean light
against
an Autumn
sky.

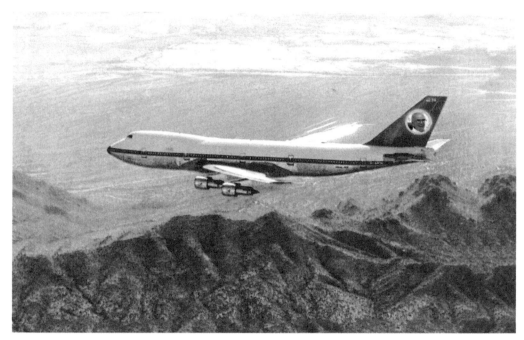

Often, after the sun has set, you can see a plane high in the sky, still in the sun.

CARMEL VALLEY
BRAND 2040

CARMEL MISSION FOUNDED 1770

PRODUCE
OF U.S.A.

PEARS

CARMEL VALLEY FRUIT GROWERS ASSOCIATION
MONTEREY CALIFORNIA

BLUE ANCHOR
CALIFORNIA FRUIT EXCHANGE

The golden sky frames
the valley hills.

Gray wandering oak limbs
outline the valley floor below,

Gathering voices of
the windless night.

In my hand
I crush the leaf
of the nearby lemon tree.

Other times and far-away
places come to mind.

CARMEL VALLEY
EVENING

Time remembered,
ancient waters,

speak softly
to the rocks.

Heat of ages…

PFEIFFER BEACH

Lonely sands, strong rocks,
grey beach.

Fassett, Jeffers, Murphy –
had their way with you.

As the waters close in,
not a footprint remains!

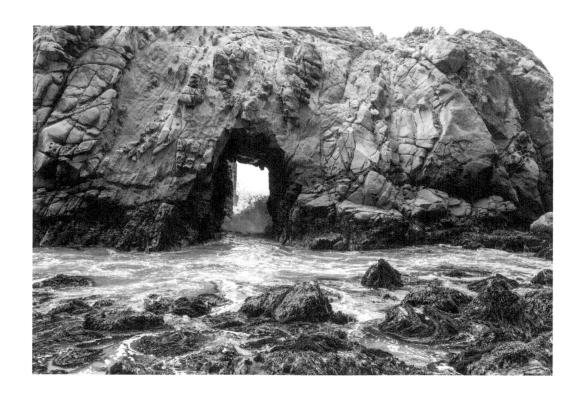

The ocean
strips clean and polishes
the wood …
Summer fires, winter rain
push the roots and branches
from the valley hills

into the raging sea.

Returned to us, among the kelp
as tiny chips,
bits of their former self

Driftwood … on Carmel Beach.

Small things of grace and beauty
from the hills
returned to our beach.

As we
did one day emerge
from the waters
to the beach,

Returned from the valley hills.

Hawk Tower in fading light,
stone set deeply into stone.

Best remembered is Lobos,
floating serene.

A razor blue line sky
is for a moment pink.

The Jeffers sea, cypress and rock,
fade once more to darkness,

leaving yellow stars
in a lavender sky.

Meetings

Meetings are interesting
as
ideas and faces
reach into the room.

Action items, workshops,
buyers, seasons.

Lots of stuff.

Behind the faces
there are people.

Sometimes!

Robert Sr., Robert Jr., and Audrey Talbott.

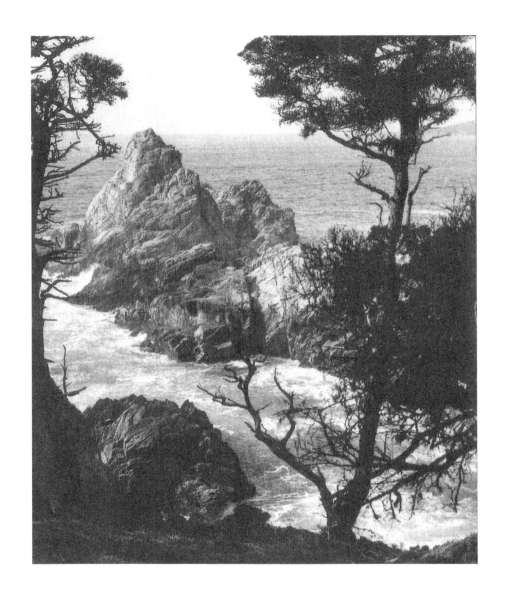

Pound, crash, break.
Foam and sand,
beat, dissolve, shatter.
Force of white water.
The boat prow
of cliff
moves forward
into the clean
blue-grey
line of sky.

Alone
+ 70"s
heavyset,
table for two,
by the window,
one chair missing.

Straight up,
Kettle One, Vodka martini,
a lemon twist only.

He was positioned to catch –
a few dying rays,
over the Odello Fields,
the Stivey Fish frontal sloaps,
and the Carmel River,
where it joined the distant yellow sea.

("Everything a river should be")

Now and again,
the man
reached for –
a #6 Apple iPhone.

They GAVE their lives

so it is said.

And yet,

To give is better
than to receive.

so it is said.

THEY DID NOT GIVE

The system –
Our system of war.

TOOK!

That system remains ...

and will continue to –

TAKE TAKE TAKE

MEMORIAL DAY 2015

ALZHEIMER'S
· ·

I'm here.
You, too.

Me gone.
Not you.

So very
vulnerable …

Sun creeping
across our
Kipp Stewart deck

into our living room,

Headquarters Courtney.

Anchored by your
friendly hospital bed

our love song playing

I can speak of love.

"… falling in love is wonderful
so they say …"

John Coltrane and Johnny Hartman
1995 MCA Records Inc.

Unconditional Love

No deals.

No agendas.

Free of pain.

Memories that
glow
with gladness and
a healthy heart.

Alzheimer's too –

has its sidebar

blessings.

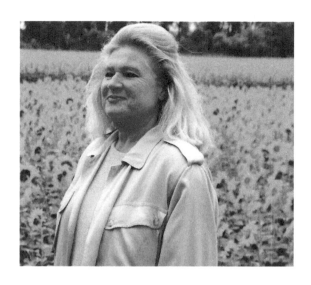

When
you find me

you will know
who I am.

Because …

I am
you

and

You are
who
I am.

I guess what is going on here is - Courtney and I can't be separated. But she can now, never know who I am.

My name is Courtney.
When very small,
my mother and I lived in
Manhattan Beach.

We had relatives there.

We had lived in Chicago.
My mother left my father.
He used to get drunk
and beat her.

Now and then my father
would call ...
We seemed to have no money.

I would ask my father to send some money.
He never did.
Finally, he never called again.

My mother's name was Valerie.
Most every evening
Valerie would swim out by the pier,
into the ocean.
I waited for her on the beach.
She would swim out of sight.

I was afraid ...

I thought
she might never return.

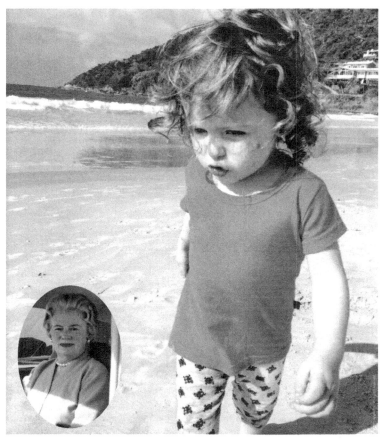

Courtney was safe in the water—she would not drown in a pool, but she was afraid of the water. Courtney did not like the beach either. (Inset: Valerie circa 1985)

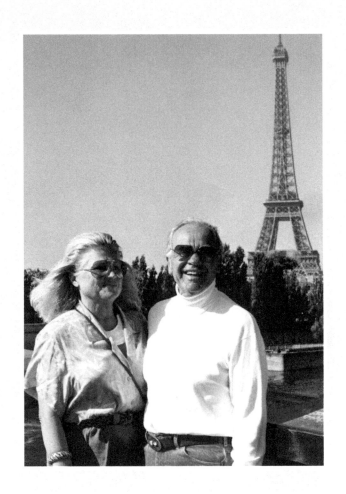

For Courtney

who needs me.

Beautiful spirit.
Beautiful heart.

I'm going
to be
with you forever.

I'm never
going
to die.

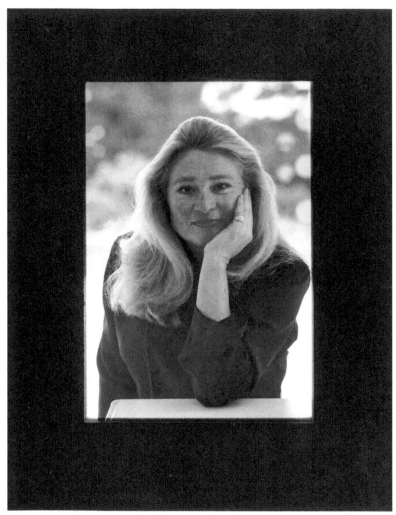

Photo of Courtney by Kipp Stewart.

We've all
got a lot
to be grateful for,

and

I'm most
grateful
for you,

and

your
unconditional
love.

The long road

Split in the middle,

With centuries of caring.

Hand holding hand,
Hearts as one,

Stars glowing dimmer -

A calm grey sea.

The long road

The long road

The long road

Difficult day,
difficult decision.

She is moving
into another's care.

Many, many
good reasons.

Judge not.

Screams

from the sidelines.

Why now?
Why there?

Why now?
Why never?

Why–why–why?

it seemed
to be
the
right
thing
to do.

No?

OK.

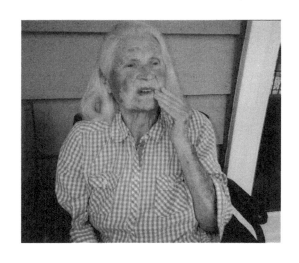

Shadow
Memories

Her shadow is with me always,
a distant memory of a distant love,

expressing itself still:

in a faint smile,
turn of her head,
still strong grip on my arm,

radiating inner beauty and strength.

While …

sliding quietly into year five,
and the uncertain future
for us both.

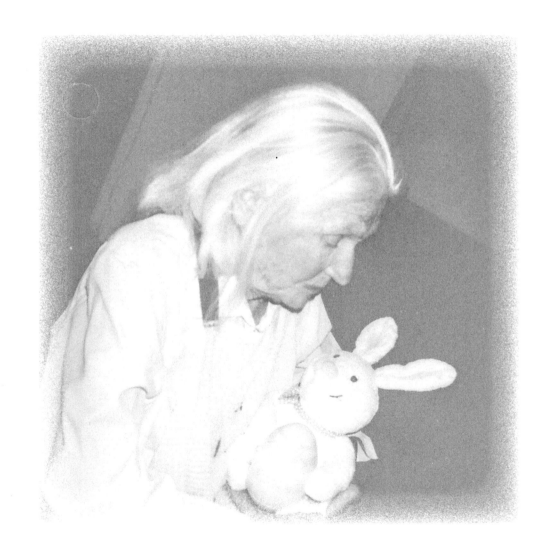

The registered nurse called it
"the process."

Look it up.
No, don't.

"My dear, it is part of the process."

Not so.

She is not part of a process …

There is still
love,
life,
and beauty,

as her great,
strong
spirit shines
through.

One bright star
dancing with the many.

Bingo.

You cannot hold my hand.
I have to go alone.

Be careful what you say.
Now and then
I hear you …

You have your cosmic presence.
Perhaps mine is
alive and well,

But,
under the largest black rock
or in the wind-torn,
raging sea.

Touch me – this is important.
I need to be somewhere.
You can't help me.

Words in the wind,
wind words.

My home is on
the dark side.
And so it is …

Stage Five: "At this point your loved one cannot function at all without help." These words are about C.B.'s "cosmic" presence.
 "Relating to the universe or outer space ..."
 And ends with: *"spiritual matters."*
 Contains the idea of where only the black wind blows ...

This morning
I was helping her
eat breakfast.

As I often do, I told her,
"I love you."

Looking me in the eye,
and with a slight smile,
she said:

"Thank you."

Why did they
do this to us?

Not just you,
me too.

this plan leads
to being with the sky.

And not being able
to softly embrace the light

or keep the water and sand
alive and singing.

The Lobos rocks are split apart.
Our hearts and minds
dissolve.

I was driving around Carmel Point alone
with Courtney—lovely evening—quiet.
Warm with windows down.
Not being able to get Courtney to focus beyond the inside
door handle and the windshield, and to see beyond to the
outside was frustrating …

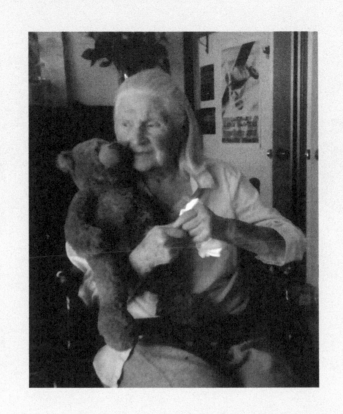

I held both her hands
and said:
"Sometimes I'm sad."
Sadness came into her eyes.
I thought
sadness reflected back and forth,
her eyes to mine, mine to hers.
I thought.
Contact …
Not really.
Not possible.

NOT REALLY

Your mom may have told you:
"You're too old to cry!"
I'm too old not to cry.

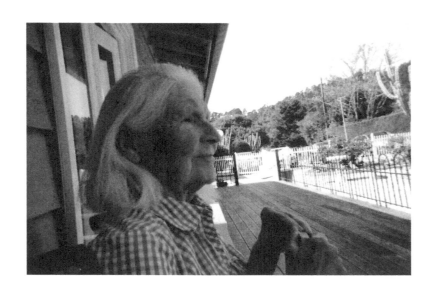

THE BIG TEDDY STORY

......................................

COURTNEY HAS HAD A SPECIAL "TEDDY" FOR SOME YEARS.

In January 2012 there was a major after-Christmas sale at
Long's Drug Store. I found a really large Teddy bear for $19.95.

This bear was really big, almost like a small child.
I was sure Courtney would really be excited by Big Teddy.
It didn't happen.

Courtney almost ignored Big Teddy,
did not warm up to him at all. I finally asked Courtney:
"What is it about Big Teddy that you don't like?"

Without missing a beat, she replied:

"HE EATS TOO MUCH!"

You may have visited the Radiation/Oncology section of the hosptal, but then, perhaps not.

It is at the very north/north end of CHOMP, a separate entrance with lots of steps down to the large area—actually underground—extending north under the road and parking area.

The doors into the treatment room center itself are a few feet thick— massive—like a giant safe. The treatment area is quite small. The computer program focuses equipment to the area of the body being treated … very high tech.

Lots of support work and often surgery before this step. I did 45 weeks at five days a week, plus chemo at another location once a week. And go back every six months—perfect result.

Three MDs fulltime are doing this and only this. Twelve to fifteen support people—some have been there fifteen and twenty years. WONDERFUL, supportive atmosphere.

At the same time, and I have no idea of the percentages involved, they know, and I could get an idea from the waiting room, that not all are going to be "cured" … or even go into remission.

Has to take a toll on these folks. I spoke with two of them on this subject. And, yes, it's not easy; they give out hope where there may be none.

For the men and women

the boys and girls

who do

their good work

behind

massive closed doors

THANK YOU

— *Howard Brunn*

A Valentine note
for
my lovely wife Courtney.

Always there for me
and our family.

Strong and beautiful
as
the winter sea.

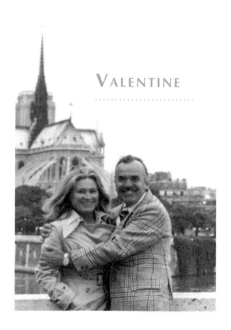

VALENTINE

Warm with the
fleeting sunshine,
south of the valley hills.

I love and respect you.

Your courage
surrounds us.

And we are better
having been
part of your light.

She died a long time ago.
Today there were tears
as her eyes glazed over,
asking to be remembered.

I remembered.

There is no day certain,
it just happens.
Now, it's not
about her,
only me.

REMEMBER

The two things that blindside me the quickest are: pain or sadness. She seldom expresses either of these. This day she was sad. We take away more than we give.

Barney Scollan, Proprietor

CARMEL BAY COMPANY
Carmel, California

September 20, 2011

Howard,

Just a quick note to thank you for all of the "Life Lessons" you have taught me over the years.

Forty years ago you showed me how to open and operate a successful business. From both you and Courtney I learned about good taste, style, and creativity. Along the way, through our association and the many opportunities it afforded, I learned how to live well and enjoy "the finer things in life."

In recent years, while caring for Courtney, you have demonstrated the true meaning of unselfish love, patience, and understanding. I hope I can do as well.

Now you are setting the standard for grace and courage "under fire."

You are quite a guy!

With love and respect,
Barney

ABOUT THE AUTHOR—HOWARD BRUNN

Carmel Residents Association: CRA Profile

by Walter Gourley, October 2003

How can CRA member Howard Brunn be described in one brief article? He deserves a full book. Wartime bomber pilot with many decorations, former actor, successful businessman, environmental activist, public benefactor, former City Council member, long-time Carmel resident, Howard Brunn seems to have done it all.

Born in San Francisco and raised in Carmel, when his father opened a garage here in 1926. Brunn has been successful in just about every endeavor he has chosen. His life story is closely entwined with the history of the village he loves.

Howard attended the Sunset Grammar School, then went to the newly opened Carmel High School and graduated with its second class. He developed a taste for the theater. He acted in school plays, and, a natural leader, was elected president

of the student body.

While in high school, he turned his attention to aviation, an interest that has never left him. Shortly before Pearl Harbor, he graduated from high school. He passed the exam for Aviation Cadet and went directly into the Army Air Corps. Stationed in Corsica during the war, he flew seventy combat missions, piloting B-25 bombers in the Mediterranean and European Theaters. He earned the Distinguished Flying Cross, the Air Medal with eleven oak leaf clusters, the European Theater Ribbon with four battle stars, and two Presidential Unit Citations.

After separation from the Air Force, Howard used the G.I. Bill and studied radio and theatre arts in Pasadena and

Westwood. In 1955 he was back in Carmel-by-the-Sea.

He'd often noticed, in Kip's Market (formerly at San Carlos and Ocean), a "beautiful blonde, living on Carmel Point, with two little girls in tow." He prevailed upon some friends to introduce him, and married his wife, Courtney, in 1960. In addition to Vance and Karen, Courtney's daughters by a previous marriage, the Brunns have two sons, Mark and David, and a daughter, Robin.

In 1956 Howard opened his first retail business, Howard Brunn's Men's Shop in the Pine Inn. "We specialized in traditional clothing," he says. "This was an innovation in the West."

From the 60's to the 80's he owned and operated Mark Fenwick Shops in the Carmel Plaza, and, along with partner, Barney Scollan, the Carmel Bay Company.

He had several other successful stores in Carmel, some of them in partnership with his wife, who had business skills and interests similar to his. Over the years, Courtney has won renown as a skilled interior designer, and recently was involved with the interior of the renovated Sunset Theater.

In the 1980's Howard joined the Robert Talbott Tie Company and worked there for seventeen years. Now retired, he continues to serve on their board. He's also on the board of Paula Skene Designs.

Howard combines his talents for business with community service. He's what the mainstream press likes to call an "activist," concerned about habitat preservation and the environment.

As a member of the Carmel City Council from 1978 to 1982, he helped organize OLAF, the Odello Land Acquisition Fund, which kept the artichoke farm near Point Lobos from being sold to developers.

He was a leader in the fight to keep supertankers out of Monterey Bay. For thirteen years he's served the Hatton Canyon Coalition as board member and treasurer, and celebrates the fact that "it will never, never become a freeway."

Howard helped in the early days of the Big Sur Land Trust and was a member of its initial Advisory Committee. Today he serves on the boards of the Carmel Preservation Foundation, the Carmel Residents Association, and the Carmel Valley Forum.

The Brunns live in a strikingly beautiful home near the mouth of Carmel Valley, contemporary in styling, with a marked feeling of openness. Howard explains that when they bought it, it was considered a "tear-down." But Courtney went to work, and thanks to her, it's a thing of beauty.

An active interest in jazz has led to his becoming the president of the very successful Monterey Jazz Festival.

A few years ago, he decided he missed the joys of flying. So, in his mid-seventies, he went to Hollister to take up gliding—powerless flight. "Mostly for the challenge of doing it right," he says. And, like everything else he does, he did it right.

Whatever he does, he once told a reporter, "I love every minute of what I'm doing."

"It is here (on the bomb run) more than anywhere else, that the bomber and her crew are put to the test. Men and machine meet the test. They sweat; they pray; their insides feel all wrong. Their nerves and senses reach an unknown peak—sometimes they shatter. Anyone who has ever been up there knows the feeling of life—life is a sweet precious thing. On the bomb run life is sometimes cheap ….

"Instruments, dials and gauges, the crowded cockpit with the clean fresh plexi-glass, the life jacket and the safety belt, warm gloves, and the feeling of the ship through their leather. Your hands, one on the control column and one wrapped around the throttles, directing and commanding the plane down the bomb run. This is your baby; fly the hell out of her! Now there is a moment of level flight—a fraction of a turn with the trim tab, a breath of pressure on the wheel, and the keen thrill of coordination and timing as you notice the perfect formation your bomber is holding.

"They told us in interrogation what to expect. 'There will be—heavy guns at the target, and in the target area!' You know what's coming, and, 'till now, you have tried to keep your thoughts in other places …. Corny jokes with the crew, a little music on the radio—anything to keep your mind off what's coming.

"Getting flak now. There is a thud and a lurch on the ship as a piece of hot metal rips through her delicate hide. 'Flak at six o'clock. They're tracking us, coming up on the tail …. Let's get the hell out of here!' Your ears ring from the shouted information over the interphone. You're on the bomb run. Hold 'er steady. How easy it would be to break away and clear out of this—how impossible!

"'Bomb bay doors open.'

"The vibration of the heavy doors is like a living thing. The co-pilot is low in his seat, a pair of wide eyes just visible under his flak helmet, and glued to the instruments. He doesn't look out. From the corner of your eye, you see nasty impersonal flak clouds bursting close. Yes, you can even smell and hear the stuff. Now steady—if ever you flew, do it now—steady!

"'Bombs away; doors closed.'

"It's a physical war from here. The bombs are gone; wrong or right, they're on their way to the target far below. Both hands on the wheel—the signal for full power; everything forward to the fire wall—dive, dive—a terrific un-real roar and scream of engines pounding out maximum horsepower as you fight the controls to stay in formation.

"'Co-pilot to crew … come in … is everyone o.k.?'

"A smooth steep banking turn, and the entire formation as one ship has changed direction. It's cold—below zero—but sweat drips off your face, your knees ache from kicking rudder first this way, then that, with all your strength. No. 3 man is smoking badly—dropping out—that would be George. 'Not now Georgie boy …

stick with her boy!' And for a brief second you think of George, then back to yourself. Still getting flak.

"Now we can move … try and outguess Jerry … be where he doesn't shoot. Suddenly it's over.

"Your hands are sticky in the gloves; your ears hurt from the pressure of the head set; your whole body is crying out to relax and stretch. You move your head in an arc to feel tensed and tired neck muscles hurt. You give the ship to the co-pilot for a while and are on the way back to base. The crew is not wounded. The ship will make it home. You may have to sweat out gas and weather—the job isn't finished ….

"The bomb run is."

by Howard Brunn
Carmel Pine Cone 1944

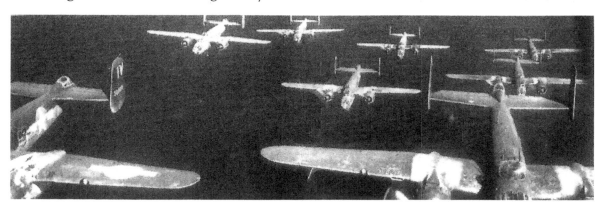

Close Formation – very tight ready for bombs away.

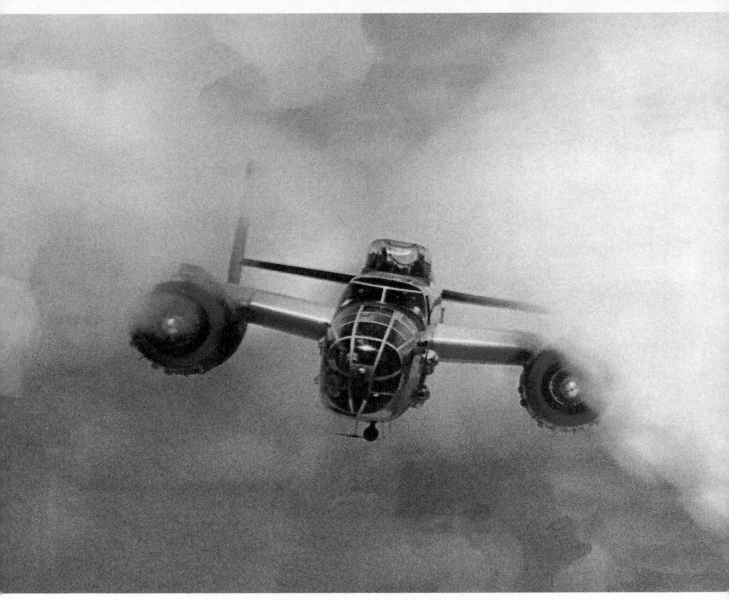

"B-25 J Billie Mitchell Bomber"

Award-winning photo of a B-25, completely restored, with a colorful Air Show paint job.
There were 15,000 produced during WWII and many were flown on "the bomb run."

PEACE...

FRANCES AND GUS
2005

In reaching for a few words to end this tome,
I am grateful to Eleanor Roosevelt:

*"Yesterday is history, tomorrow is a
mystery, and today is a gift; that's why
they call it the present."*

Flaps Up!

Howard Brunn

I kiss your eyes

I kiss your lips

I kiss your heart.

You are with me always.

And the memory
Of the flame that your
Spirit reflects …

Looks beyond:

This day

This night

This life.

Howard Brunn
August 2015

BEYOND

CPSIA information can be obtained at www.ICGtesting.com
Printed in the USA
LVOW02s1812080815

449212LV00001B/1/P